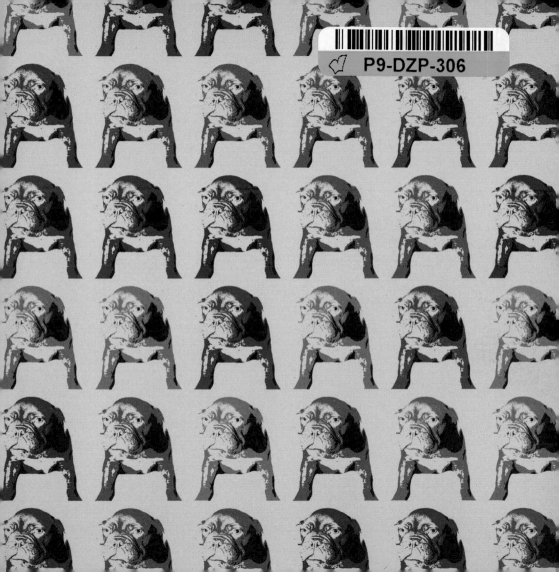

Andy Warhound
Pup Art

For Stephanie

Published by Pucci Books Ltd
120 Cowley Road
Mortlake
London
SW14 8QB
United Kingdom
www.puccibooks.com

Art Director, Illustration Design and Production
Rui Jiang

2008 2009 2010 2011 / 10 9 8 7 6 5 4 3 2 1

Cover image: Mia Feinstein

ISBN: 978-0-9559352-2-0

British Library cataloguing-in-publication data
A catalogue record of this book is available at the British Library

Andy Warhound
Pup Art

PUCCI BOOKS

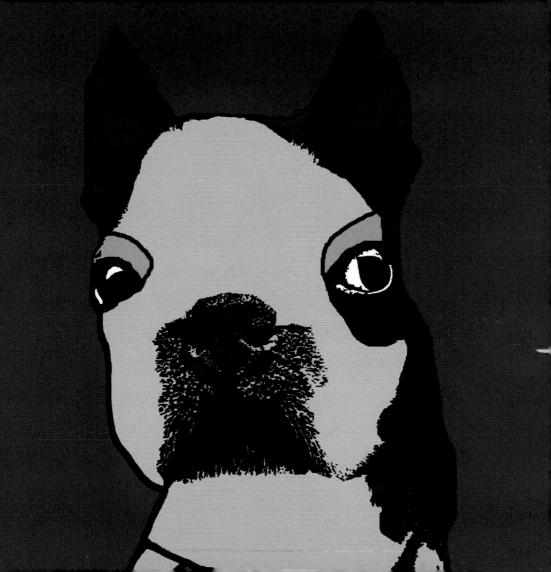

FOREWORD

Andy loved dogs: "I never met a dog I didn't like" he once said to Edie Sedgwick. He had two, Amos and Archie – the daschunds that accompanied him everywhere. They turned up in drawings (everyone forgets what a great draughtsman he was – it all started with those shoes he did for *Vogue*) and in screenprints, in blue, orange and purple. He also kept a magnificent stuffed dog – the ex-champion great dane Cecil – at the entrance to the infamous Factory.

But he didn't do enough dog – canine that is – art, and so Andy Warhound, image-maker extraordinaire, stepped into the breech. The style is inspired by Mr Warhola, and contained within are some magnificent screenprints of some famous breeds. The Bichons Frisees, Jack Russells, Highland Terriers and Pugs that have been captured for posterity are very much the pooch equivalents of Billy Names, Ultra Violets, Candy Darlings, Gerard Malangas and Nicos of now.....and just as outrageously sexy, edgy, arty, rich, famous and simply fab.

Pup Art prices too are set to rocket, but you're just ahead of the curve......so dip in, soak it up, chill out and feel the canine excess. It's priceless.

Liz Terrier

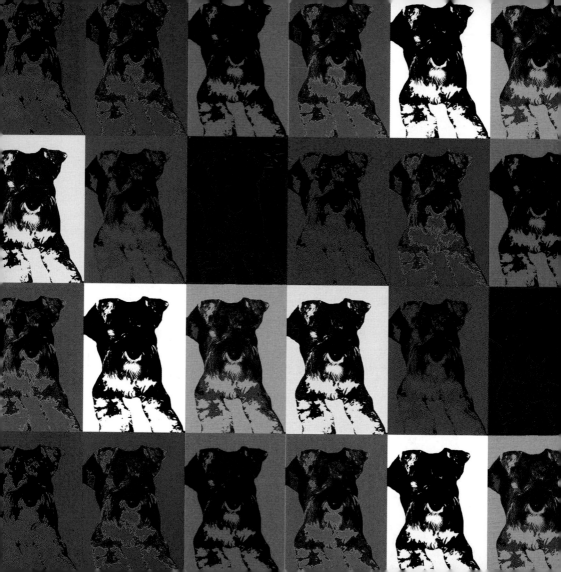

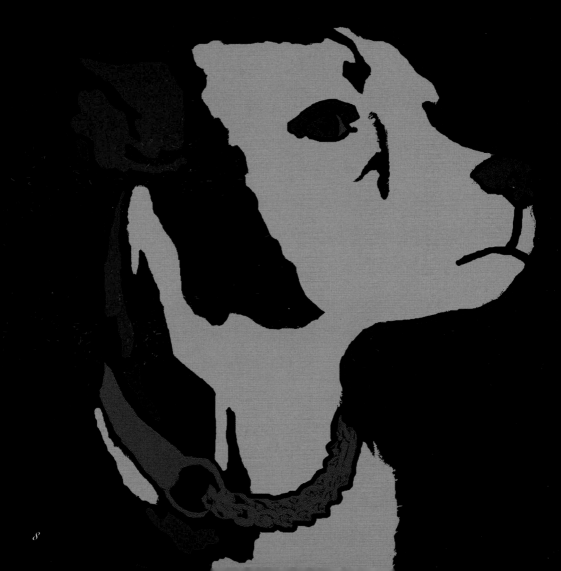

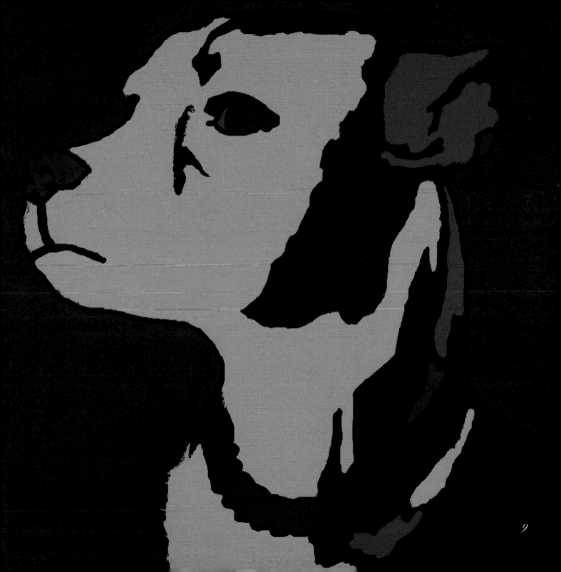

9

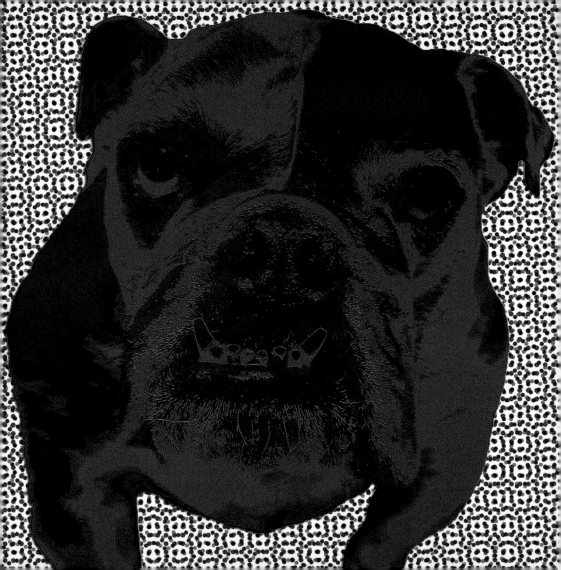

12

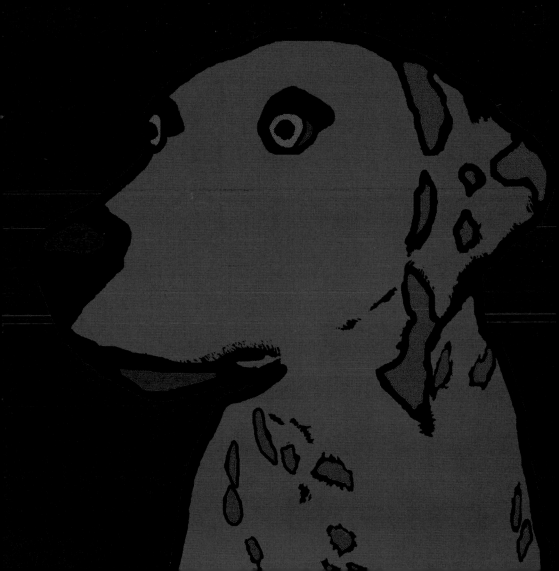

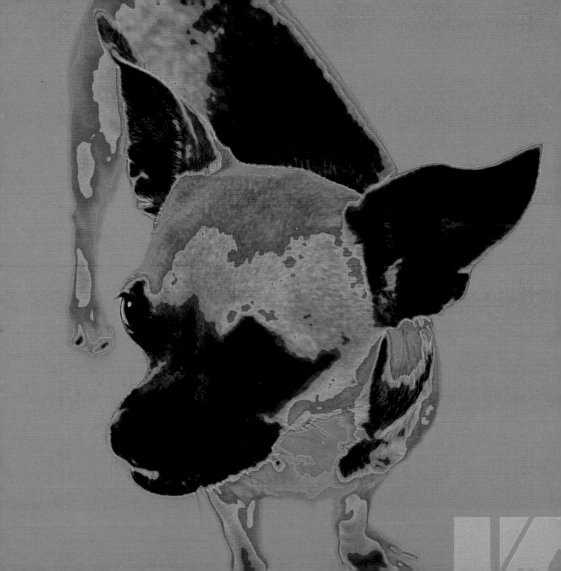

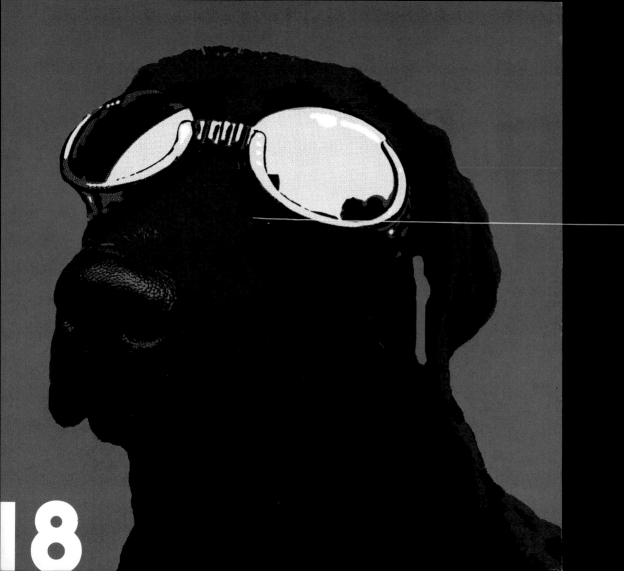

18

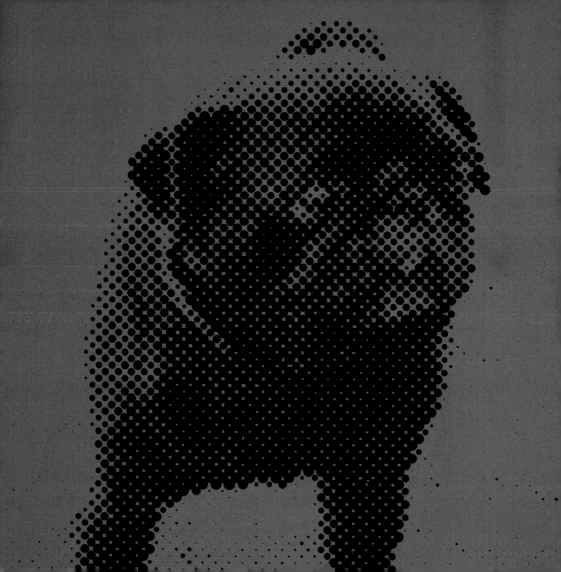

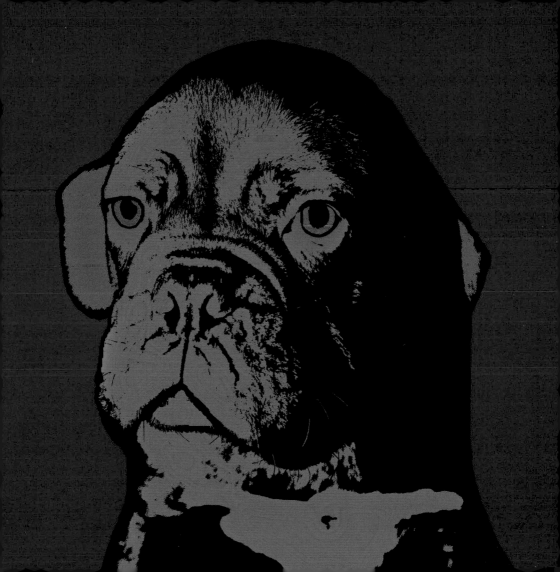

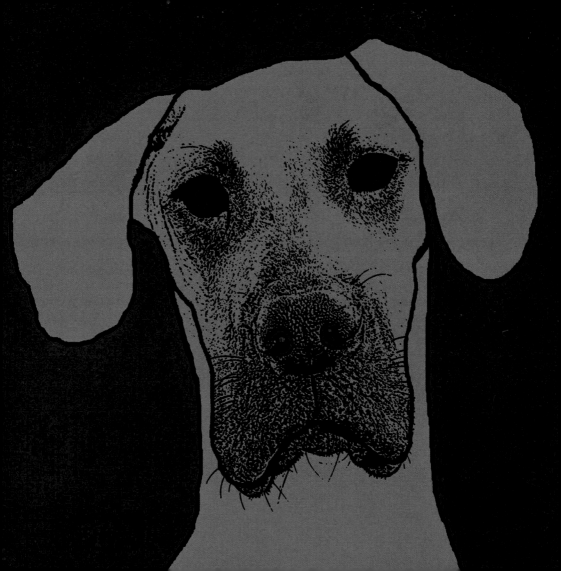

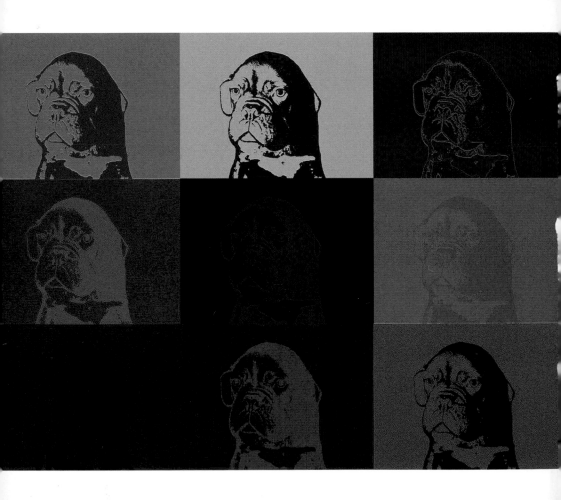

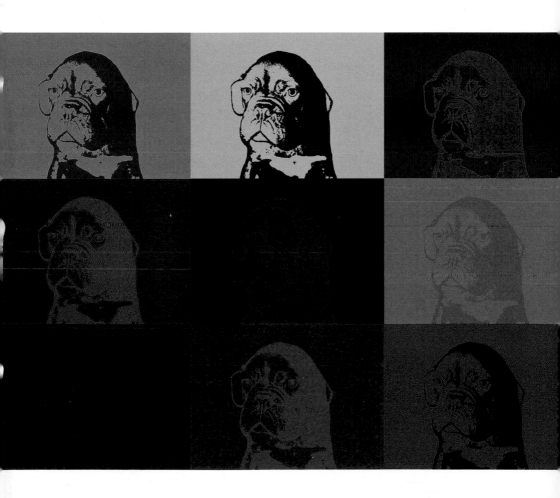

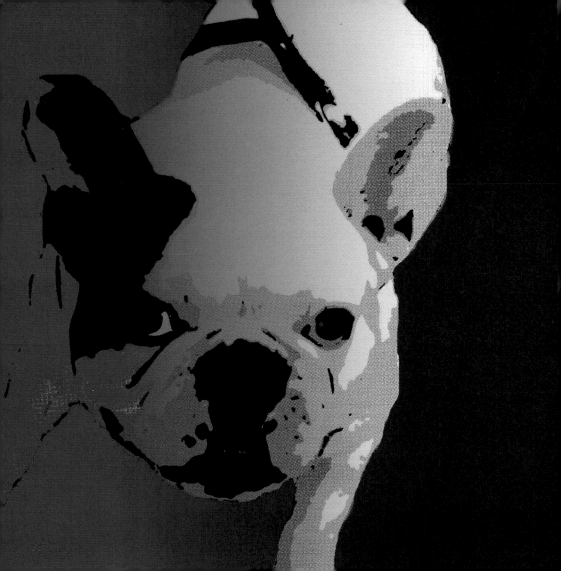

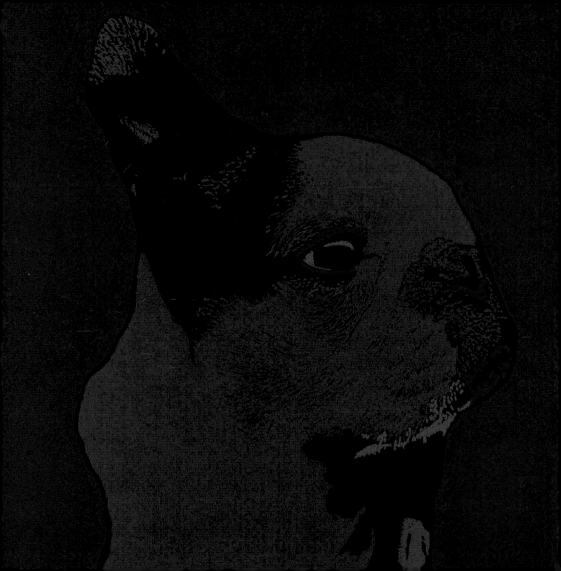

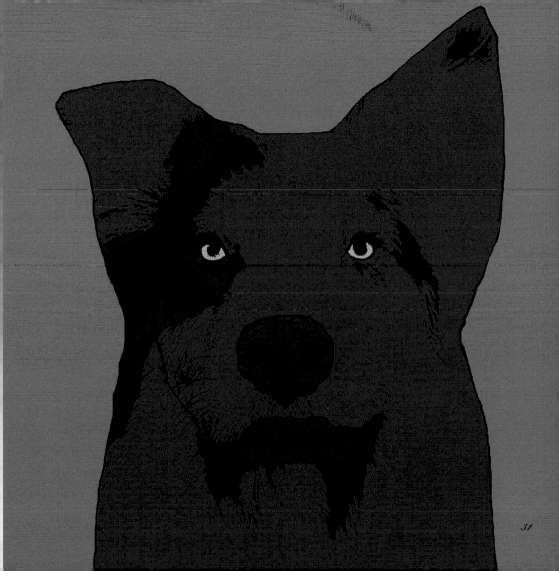

31

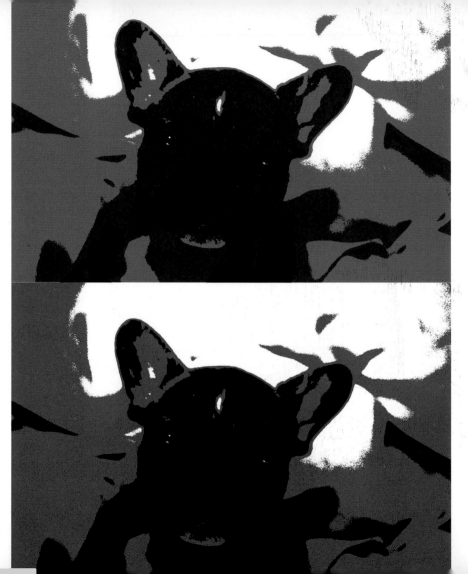

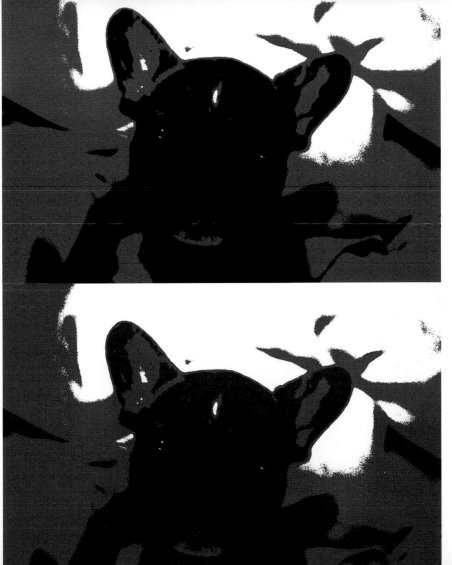

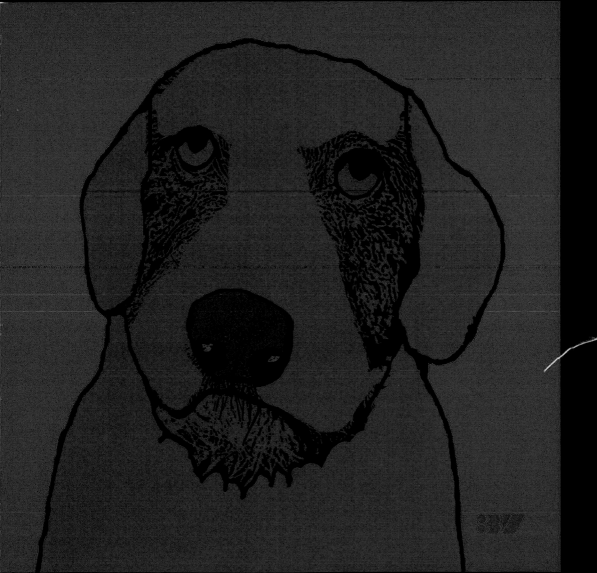

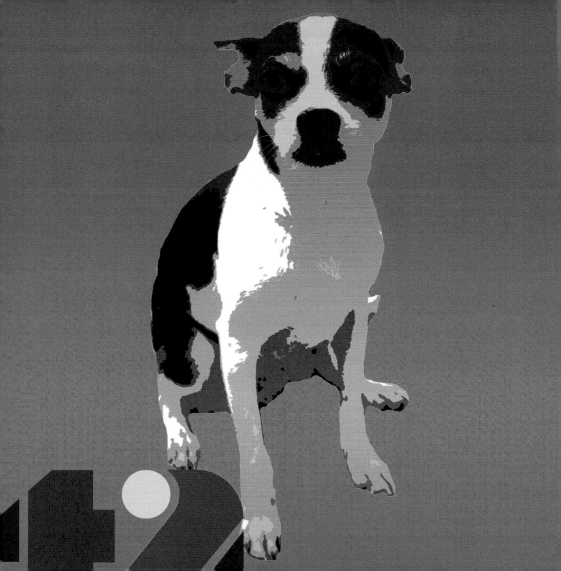

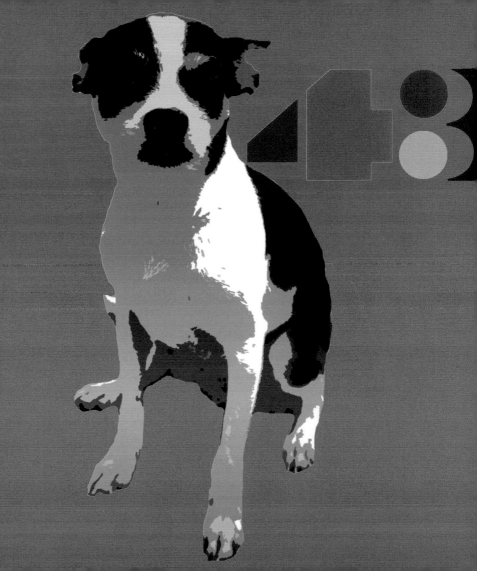

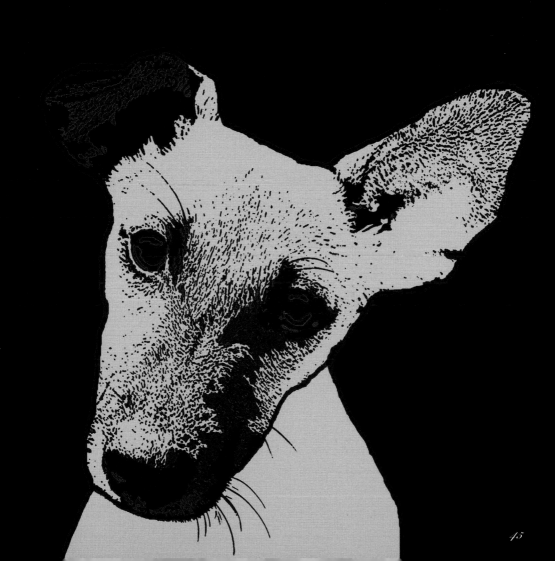

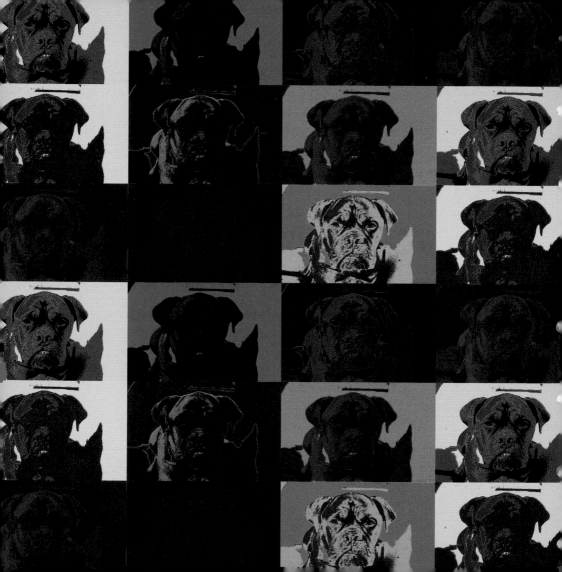

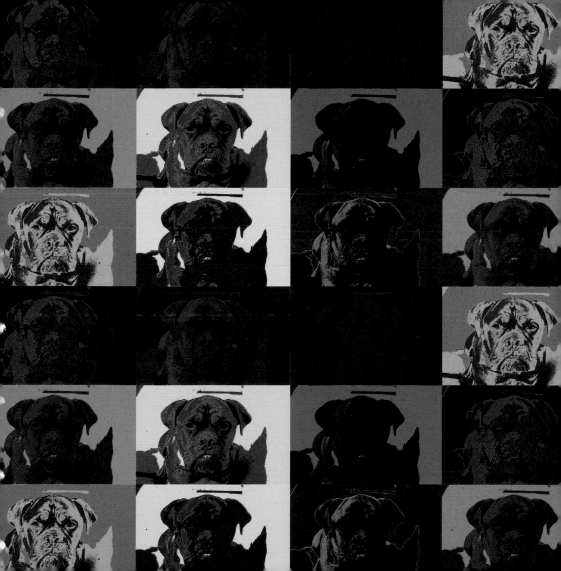

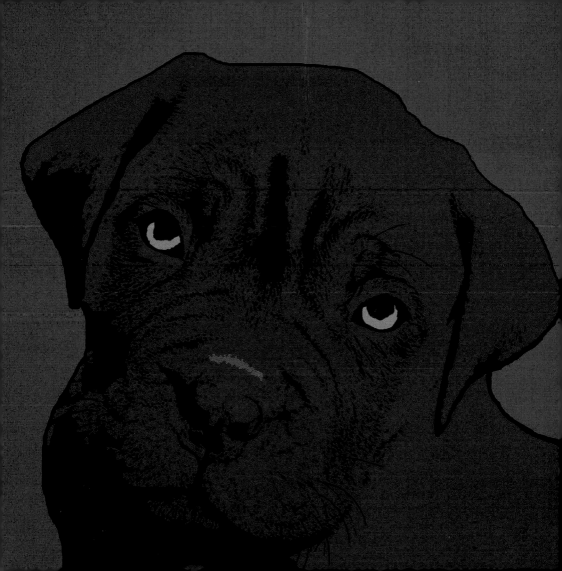

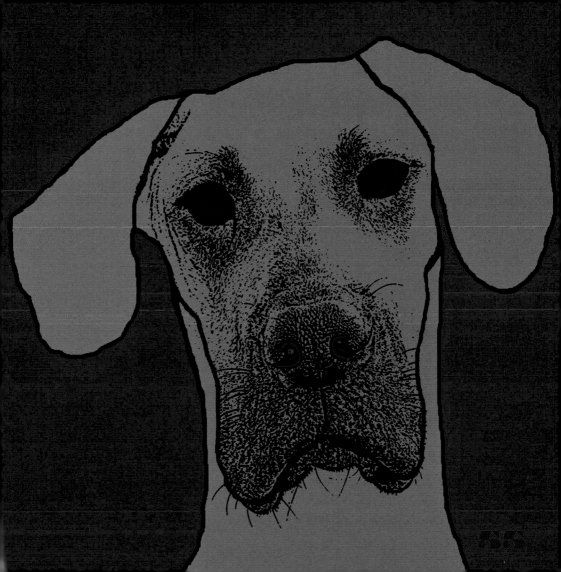

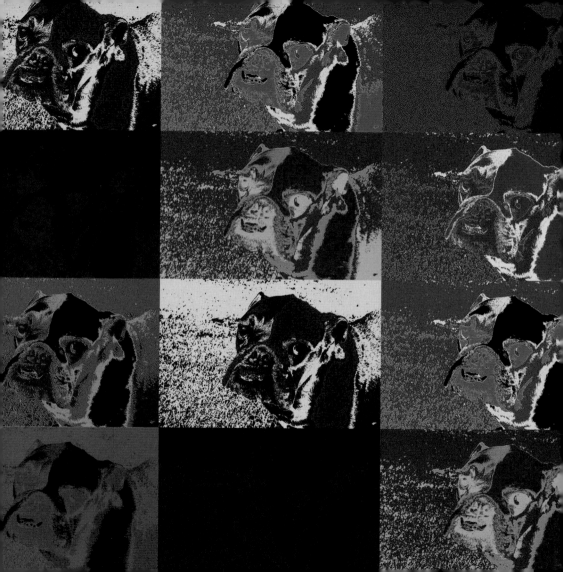

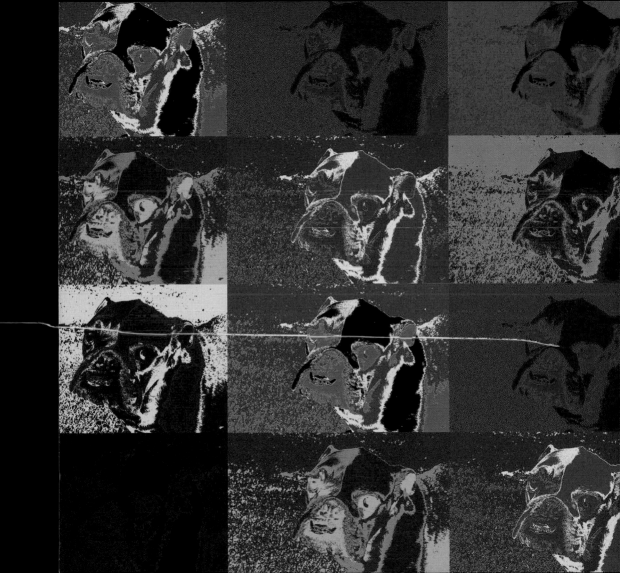

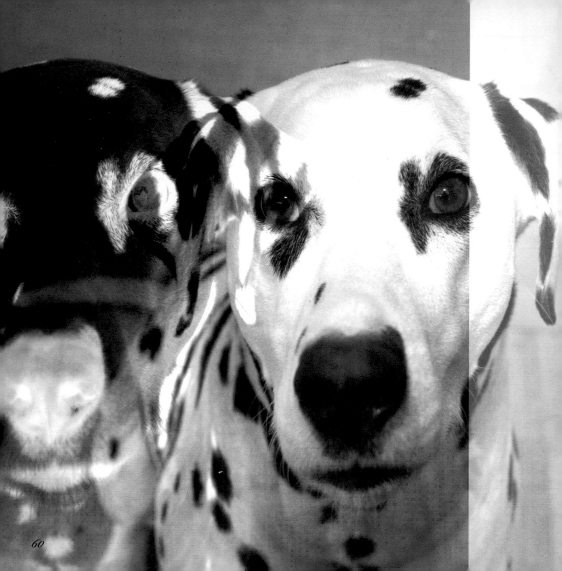

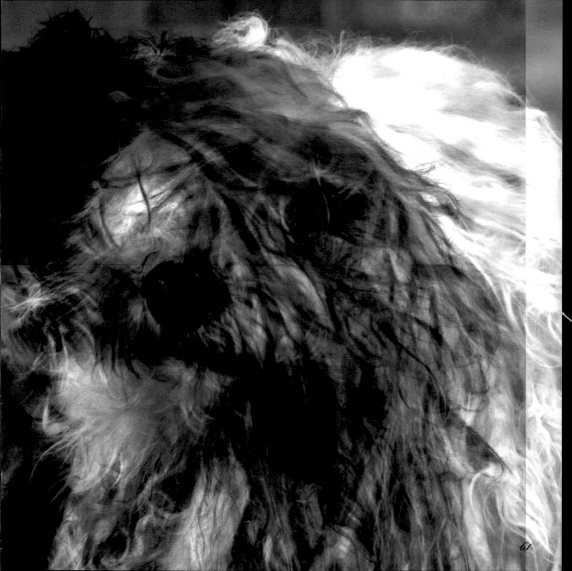

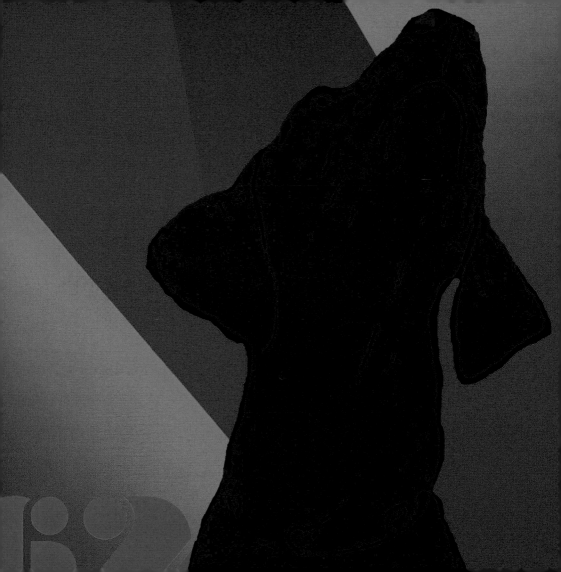

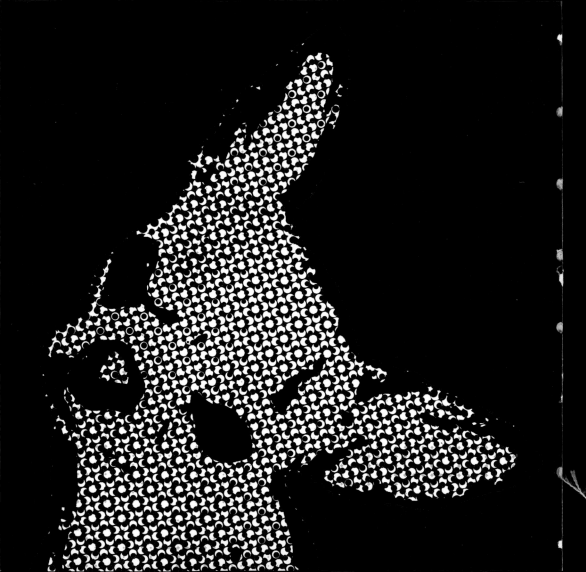

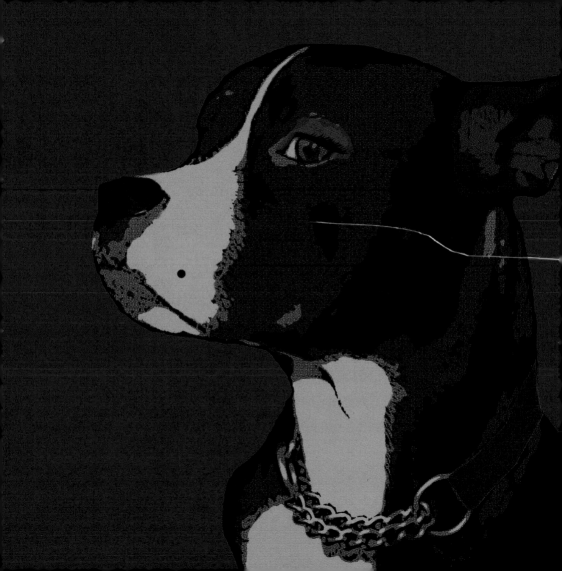

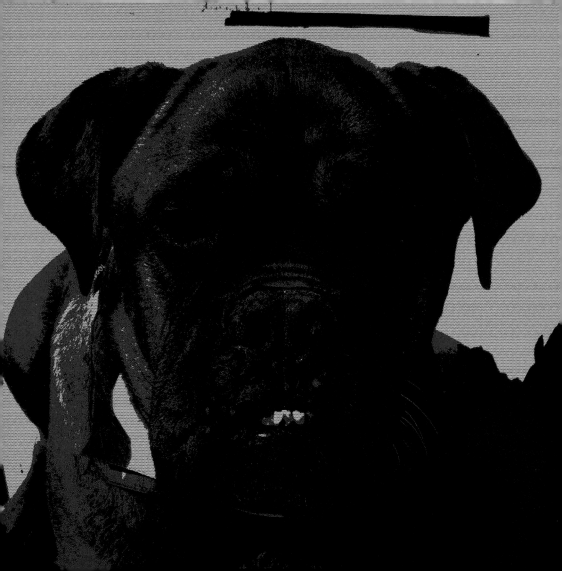

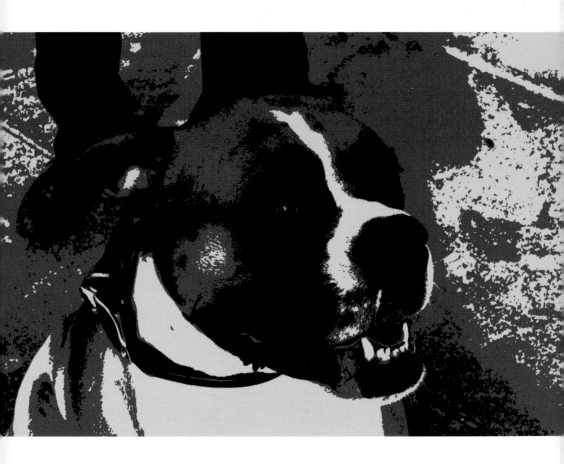

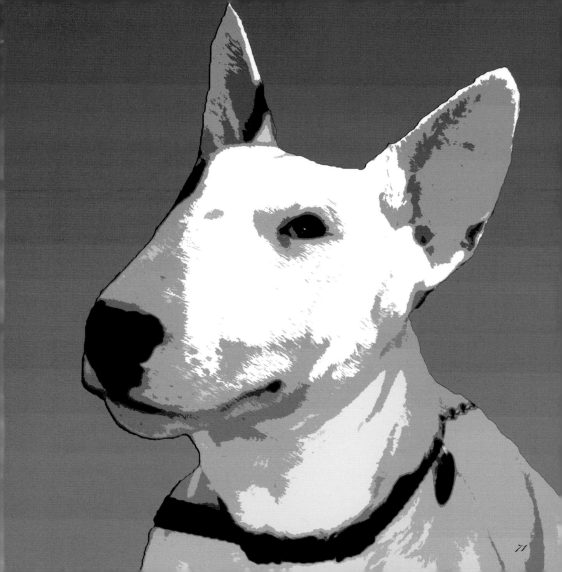

71

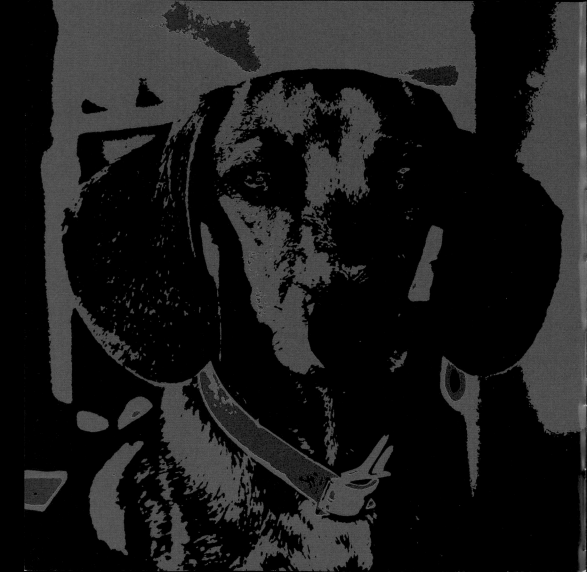

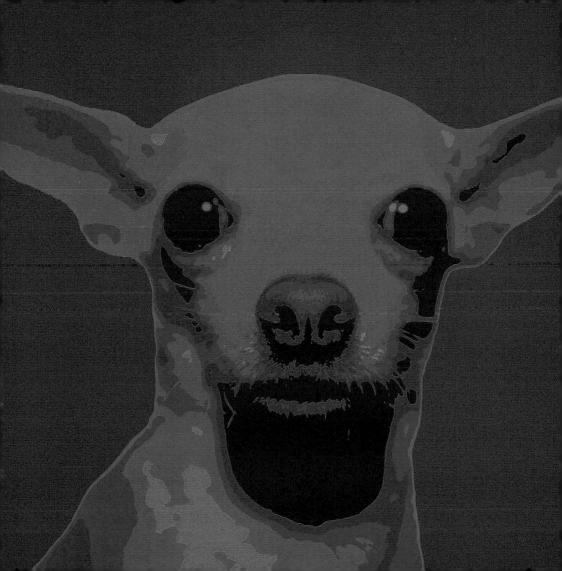

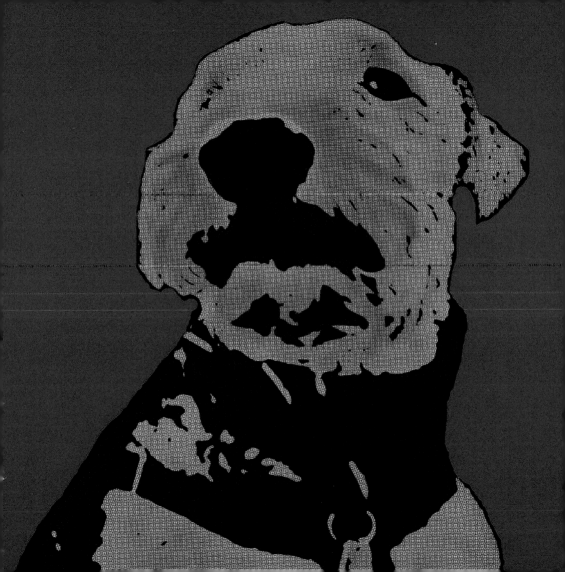

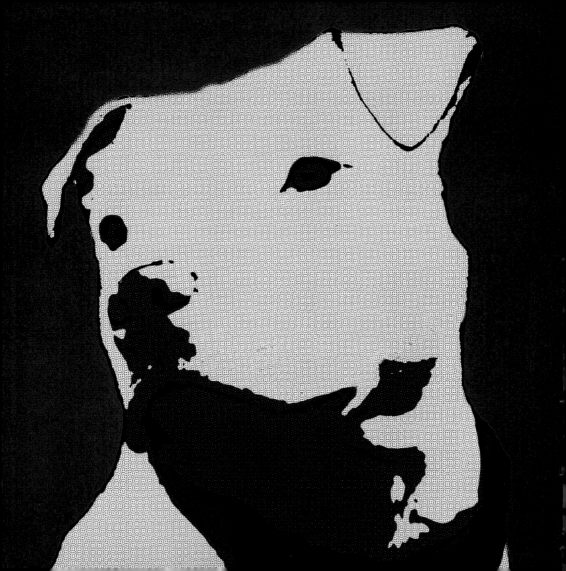

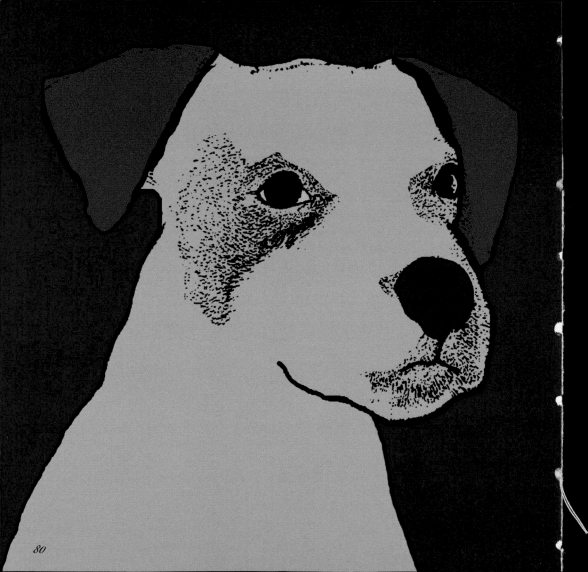

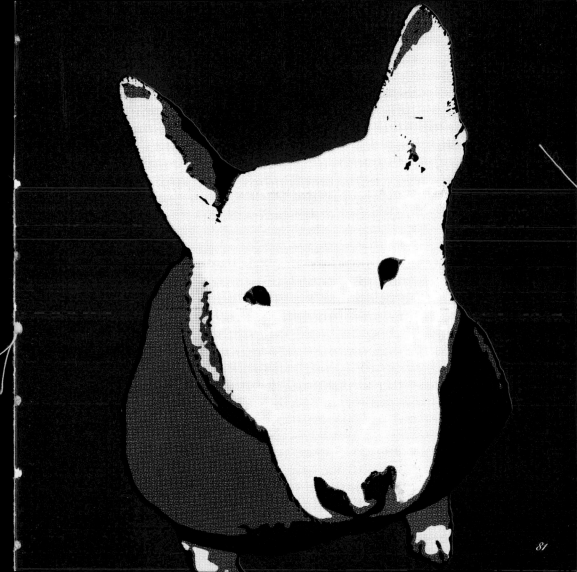

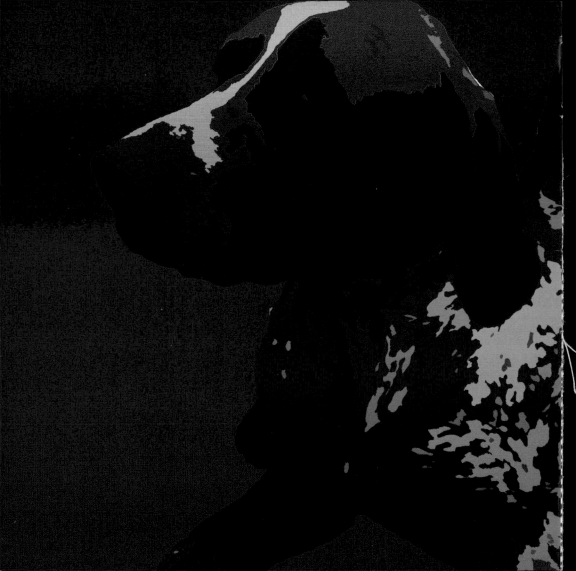

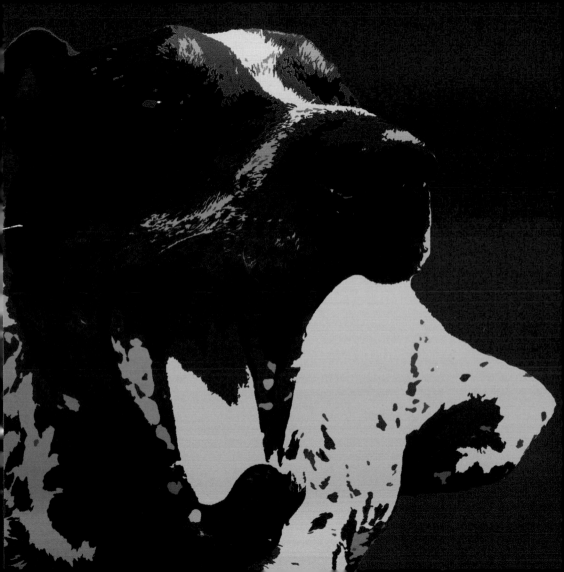

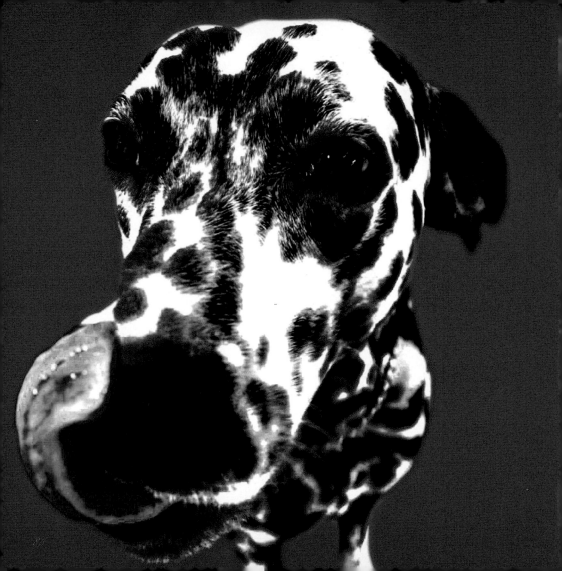

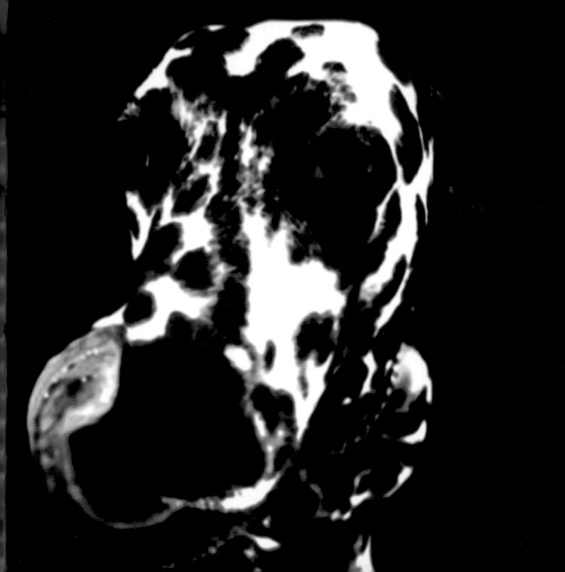

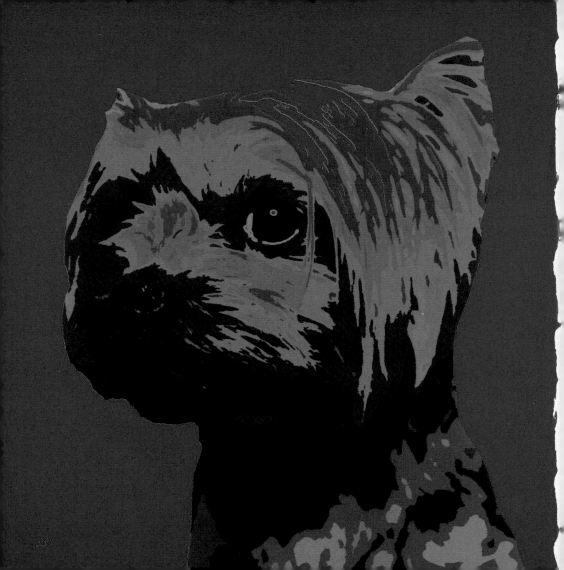

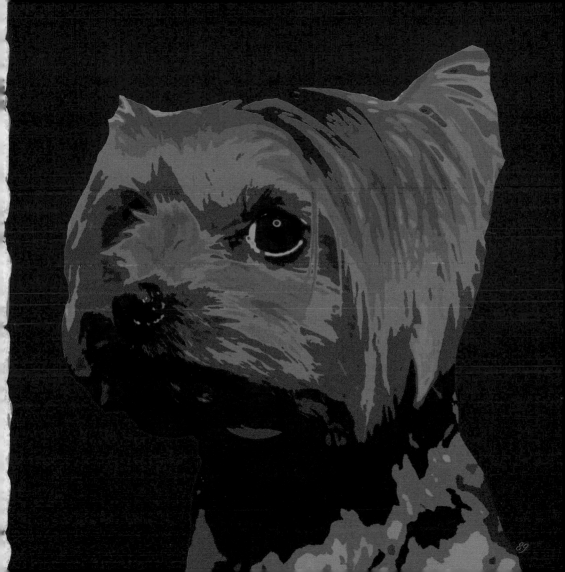

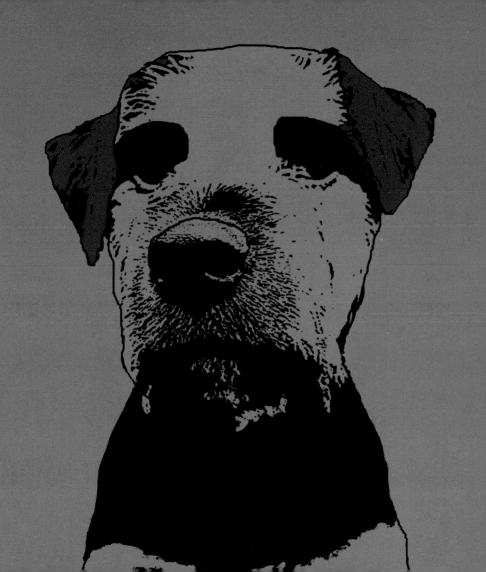

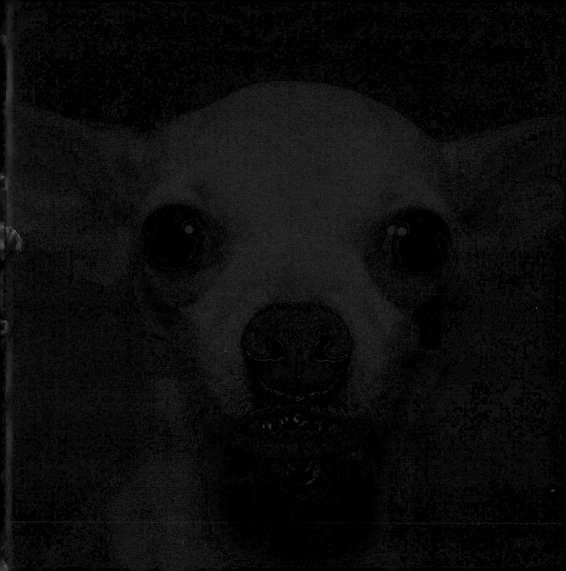

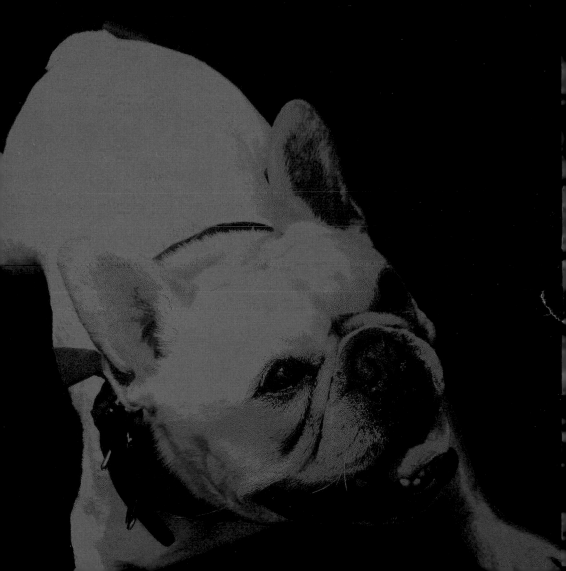

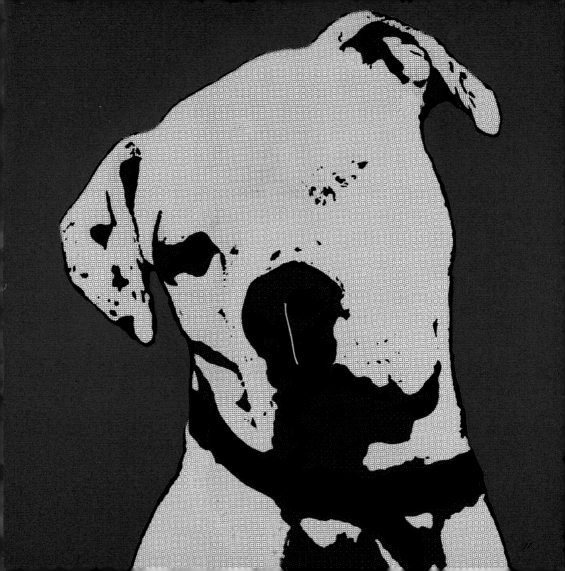

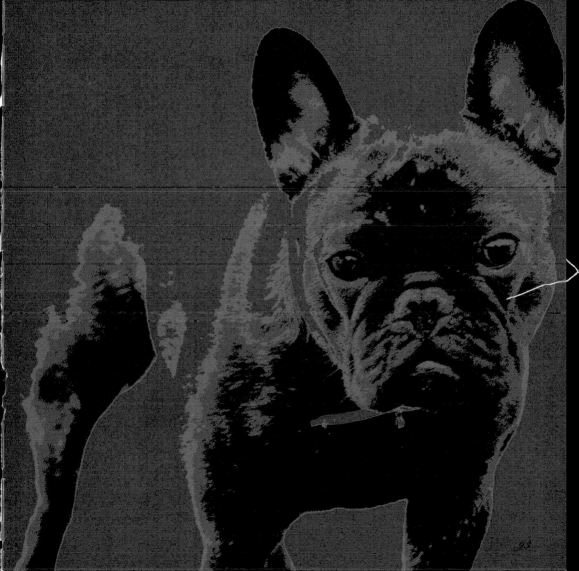

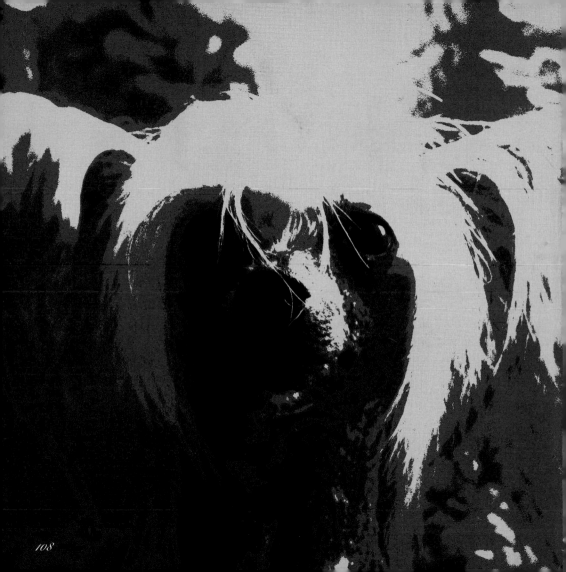

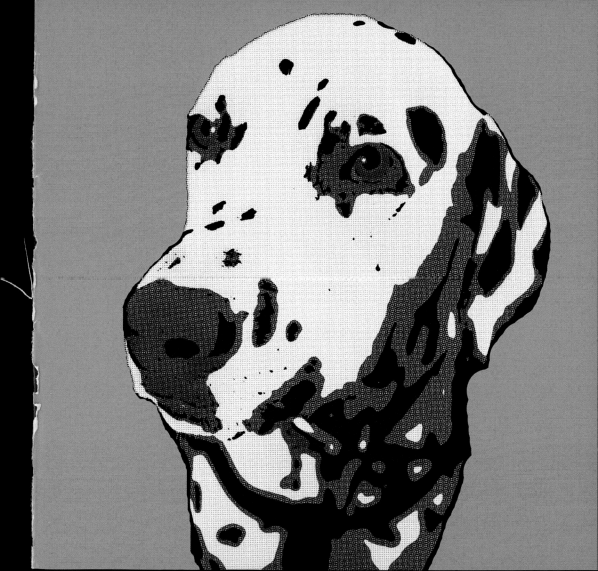

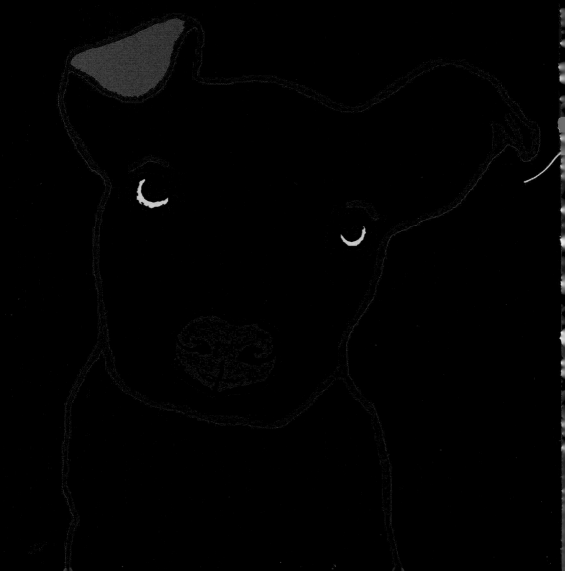

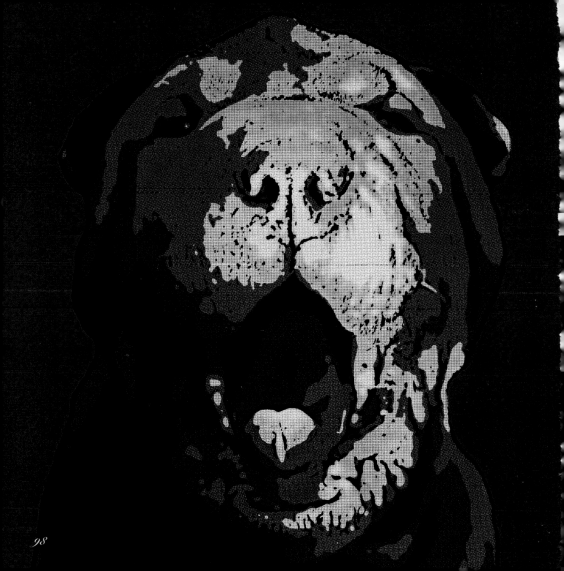

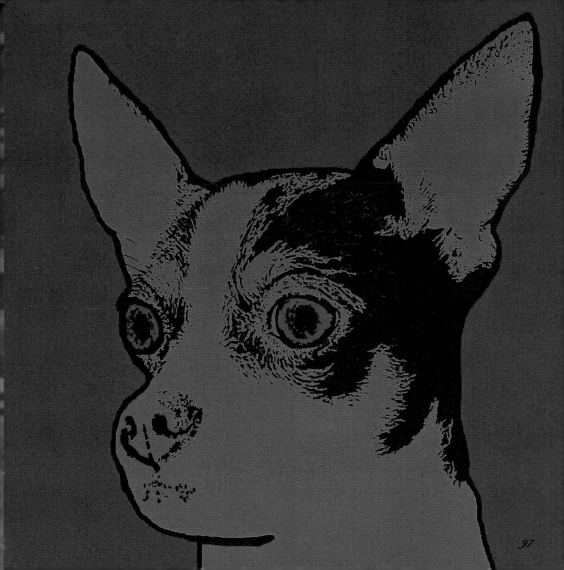

97

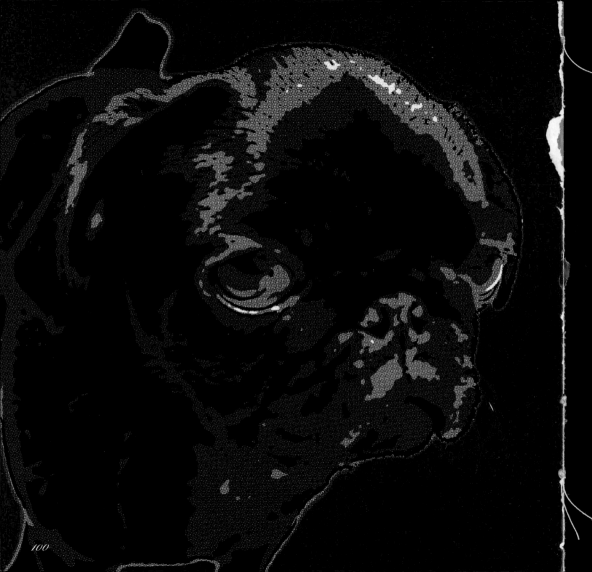

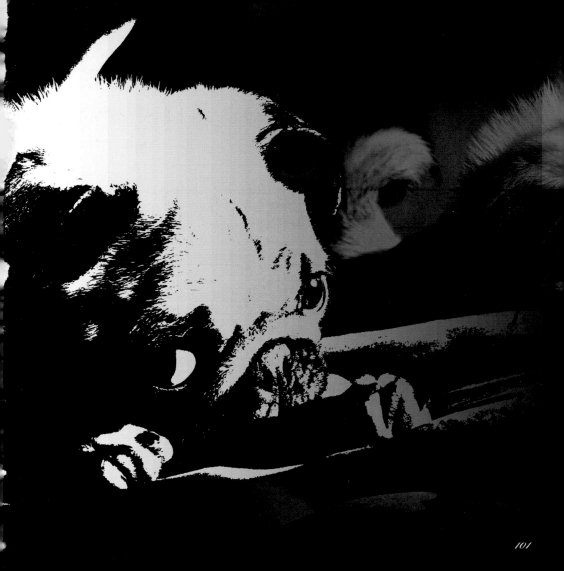

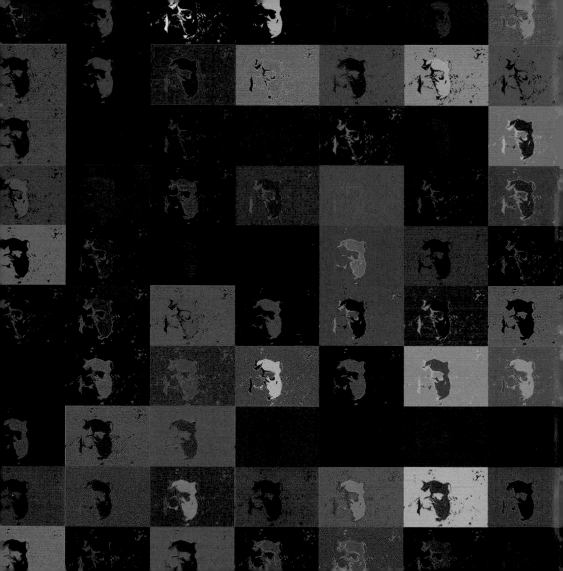

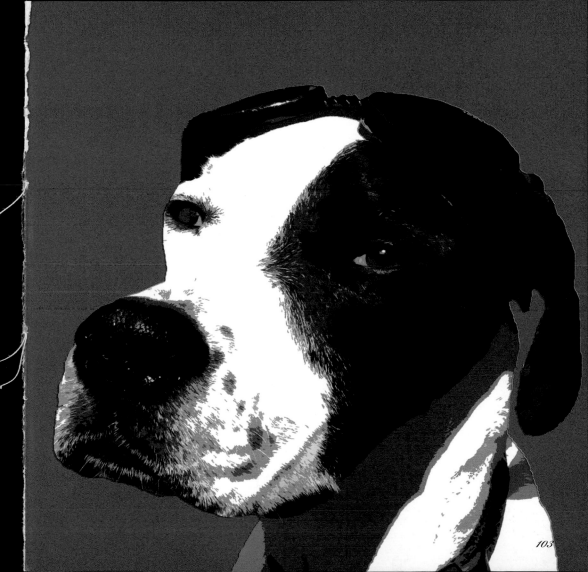

104

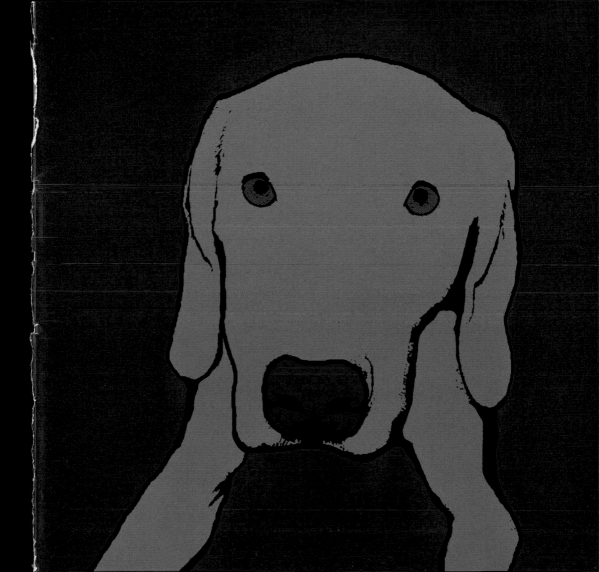

Mia Feinstein's Acknowledgements

To my publisher, thank you for believing and always having faith in me.

To Elizabeth Hurley, many thanks for your amazing testimonial.

To all the dog owners and dogs that volunteered for this books, many thanks for your dribbles, woofs, doggie licks, time and help. Much appreciated.

Many thanks goes out to the RSPCA and the Retired Greyhound Trust and to Rui Jiang.

And finally a huge thanks goes out to my friends and family. You know who you are. I love you so much. Your support and love means the world to me.